T H E
Get Well Book

A Little Book of Laughs to Make You Feel a Whole Lot Better

John McPherson

**Andrews McMeel
Publishing**

Kansas City

Foreword

I have long been a fan of John McPherson's cartoons. Because we find them insanely funny, Mark Victor Hansen and I have used a lot of them in our Chicken Soup for the Soul ®series of books. I own every collection of his cartoons that has been published, and I can safely say that this collection is certainly one of John's best—and also most useful.

Scientists have been telling us for years that when we laugh, our brains secrete endorphins—a natural opiate that reduces pain and accelerates healing. In other words, reading this book is good for your health!

When we are faced with an illness or a serious health challenge, it is important to laugh—at ourselves, our disease, our doctors and nurses, and the many forms of treatment to which we are subjected. Laughter allows us to face our fears and gain some distance from and perspective on our illnesses and then treatments. The Get Well Book will help you accomplish this in just seventy-five pages—what a wonderful gift to give to yourself and those you care about.

Get ready to enjoy a really hilarious look at the foibles of the medical world.

—Jack Canfield, coauthor, Chicken Soup for the Soul ®

For Griffin.

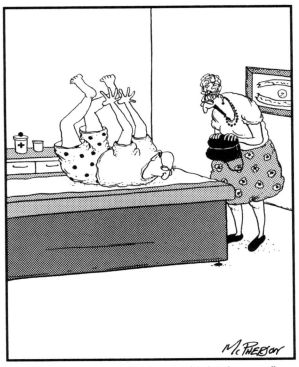

"The doctor says it's just a pinched nerve."

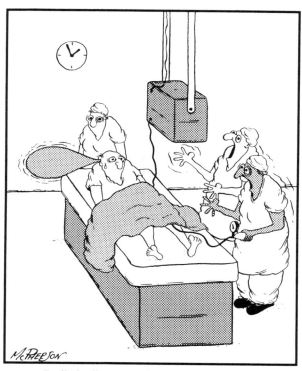

Ted's balloon angioplasty procedure
gets off to a rough start.

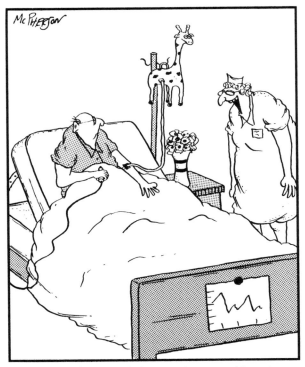

"When Fufu's head droops down and touches his knees, you buzz me!"

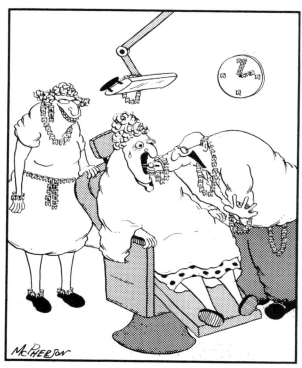

"Oh, my! This is *much* worse than I thought! I'm
afraid we may have to pull *all* of these lower teeth!
Take a look and see if you agree, Ms. Cornstock."

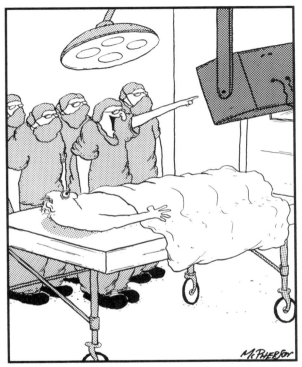

"Stop the tape! See what George Clooney is
doing with that catheter? That's the procedure
I think we should try with Mr. Simkins."

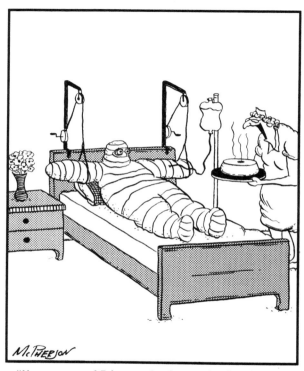

"Here you go! T-bone steak, mashed potatoes,
and fresh asparagus! Whoops! What am I doing?
This is for Mr. Cagner in room 173."

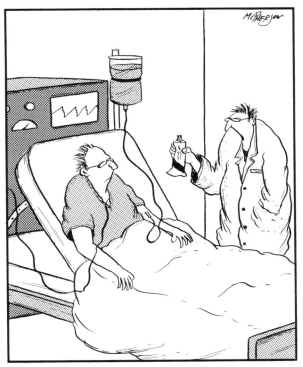

"There are two divergent opinions on how best to treat you. I'm convinced you need a triple bypass. Your HMO says all you need to do is rub this $14 tube of salve on your chest."

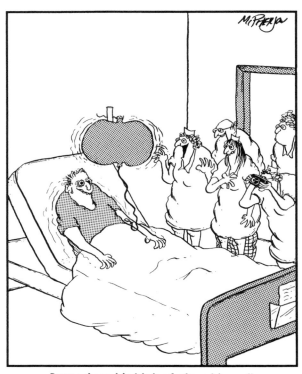

Barry does his trick of clenching all his muscles at once and getting his IV bag to expand.

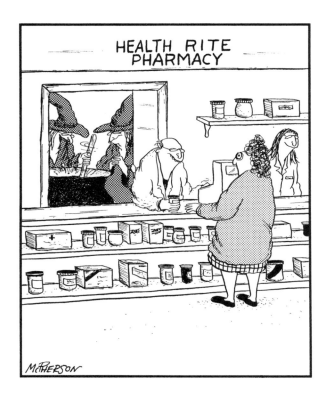

HEALTH RITE PHARMACY

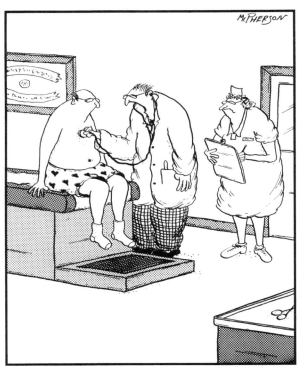

"Joyce, write this down in Mr. Cutler's file: 'thump . . . thump-thump . . . thumpety thump . . . boink.'"

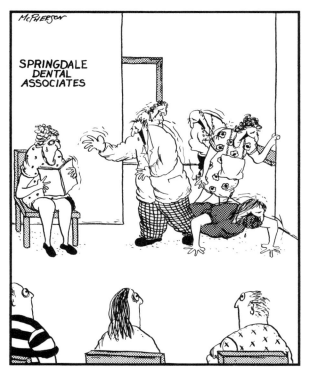

"Everyone . . . ah, ha, ha! . . . get out of here!
We've got a . . . ha, ha . . . leak in our . . . hee! . . .
laughing-gas tank! Ooo-wee! Ha, ha!
Go on, you scamps! Shoo!"

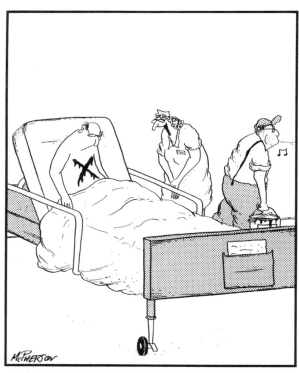

"Okay, Mr. Feldman. You're all prepped for
surgery."

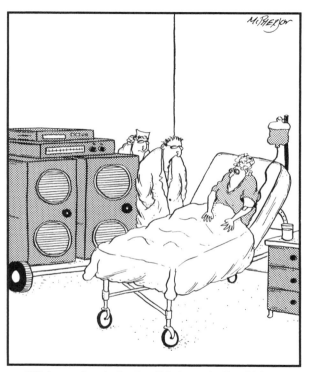

"We're going to try to disintegrate the kidney
stone with a three-hour barrage of music
by the rock band Pearl Jam."

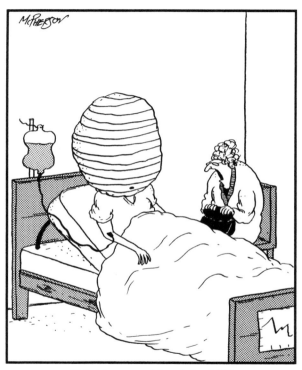

"I *told* you not to pick at it!"

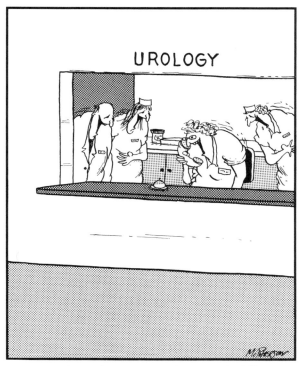

"Urology department. Can you hold?"

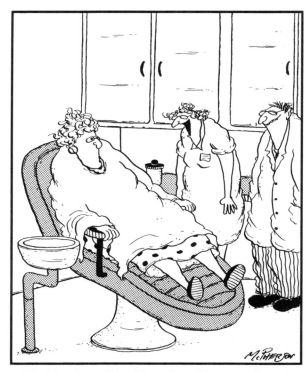

"Dr. Vernley prides himself on his commitment
to 100 percent organic dentistry. Today he'll be
using bamboo drill bits, a yucca extract
painkiller, and adobe fillings."

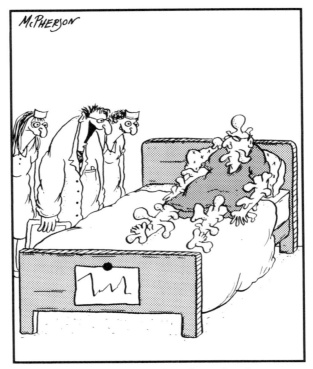

"Congratulations! You're going to
have a disease named after you!"

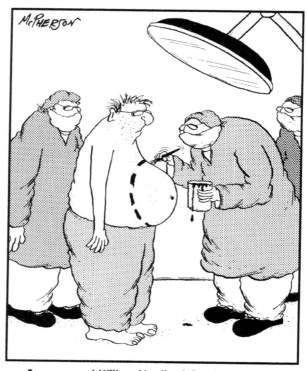

Surgeons at Wilton Medical Center prepare
for the world's first beer-bellyectomy.

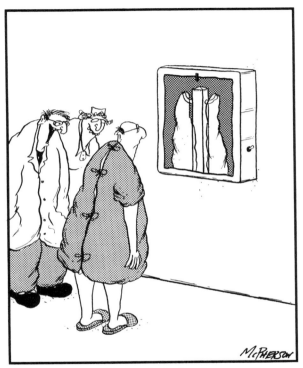

"We were pretty worried about you until we discovered that the power on the X-ray machine was set way too high and we had actually gotten an image of a coatrack in the room behind you."

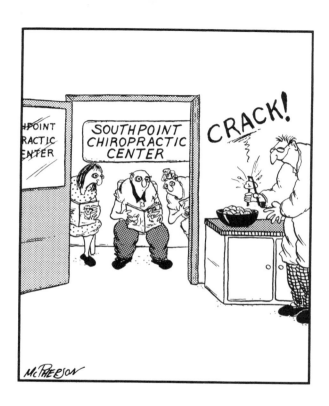

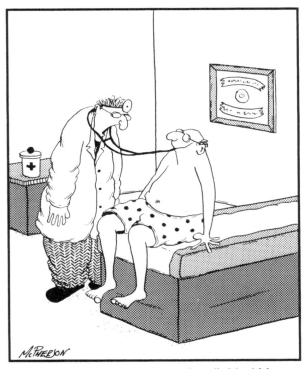

"Mr. Farnsley, I haven't got the slightest idea what song you're humming. Please take the stethoscope out of your mouth."

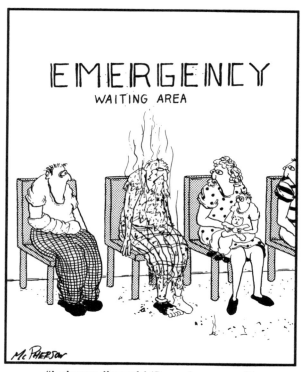

"I always thought 'Do not open until
Christmas' was just an expression."

"Your HMO allots only one hour to perform
hip-replacement surgery. After that, our candy
stripers Chip and Brenda will take over."

"Whoa! Up 14 pounds since November!
What'd you do? Get a job at a doughnut shop?!"

"Well now, Mr. Fenderson, what
seems to be the problem?"

"We have no idea what you have, Mr. Schaad,
but whatever it is, it's extremely contagious."

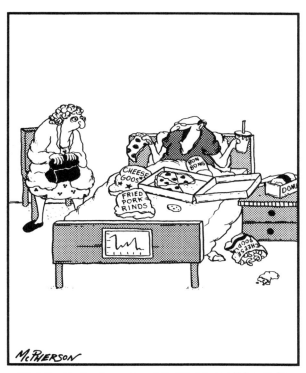

"But that's the beauty of it, Rita! I don't have to worry about my fat intake today. I'm having a quadruple bypass tomorrow!"

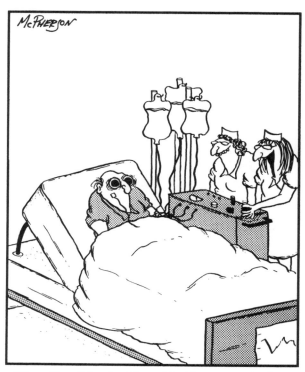

"Hey, Carol! Look at how big his eyes get when you turn this blue dial way up!"

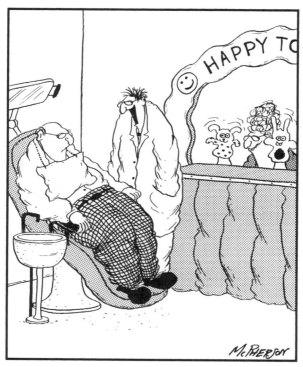

"To help distract you during your gum surgery,
Ms. Parker will be performing one of
her engaging puppet shows."

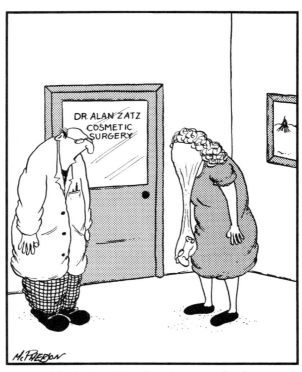

"Unfortunately, Carolyn, your body
has rejected your face-lift."

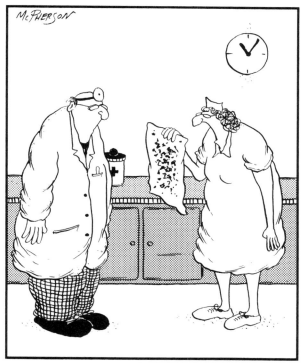

"Mrs. Nortman just sent in this fax of a rash that she's got on her stomach."

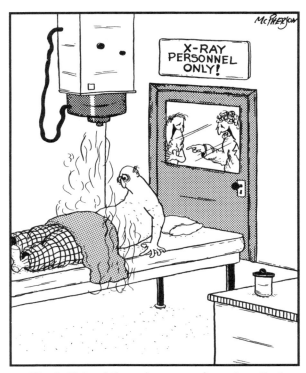

"I'm tellin' ya! Ever since you rigged up that smoke machine under the table, I just can't *wait* to get to work every day!"

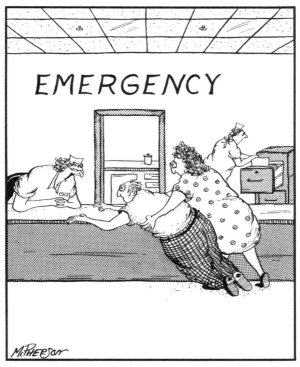

"Well, I'm sorry, but if you don't have a
receipt for the pacemaker there's
not much we can do for you."

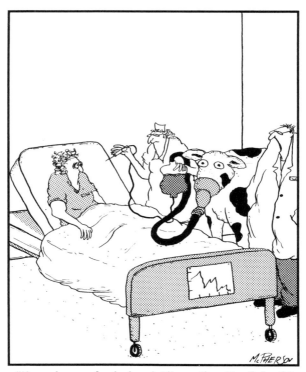

"How do you feel about Alternative Medicine?"

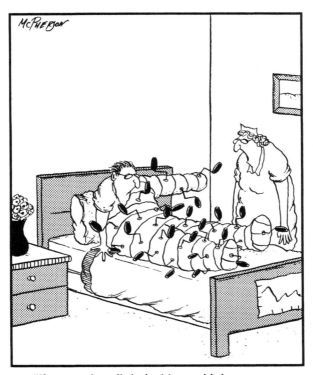

"If you get an itch, just turn whichever one
of these cranks is closest to it."

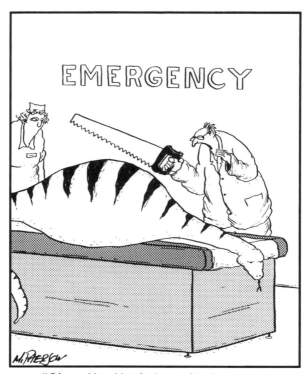

"Okay, Mrs. Morris. I need to have you
scoot as far to your left as possible."

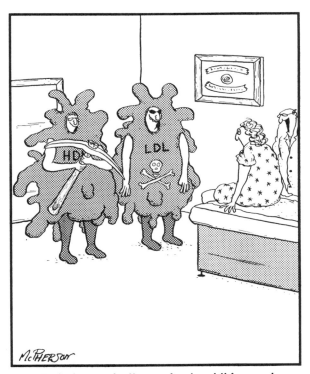

"To help you better understand this good cholesterol/bad cholesterol thing, Nurse Bowman and Nurse Strickling are going to do a little skit for you."

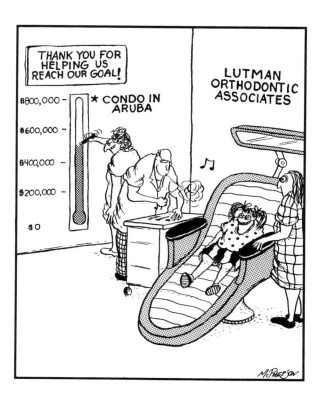

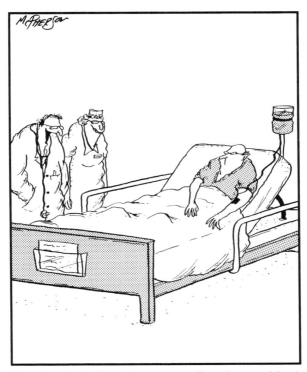

"How ironic is this? Here I am telling the president of one of the nation's largest HMOs that the surgery he needs isn't covered by his insurance!"

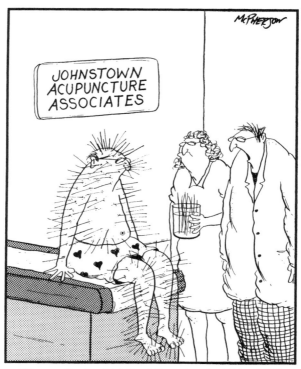

"You gotta be kidding! Your back *still* hurts?!"

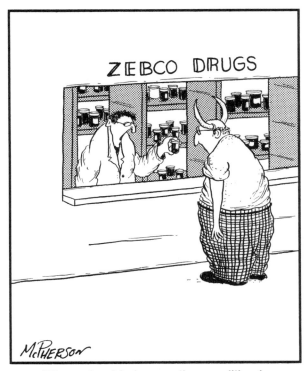

"These should clear up the condition in about 10 days. However, if you notice the slightest sign that you're growing an udder, call your doctor immediately."

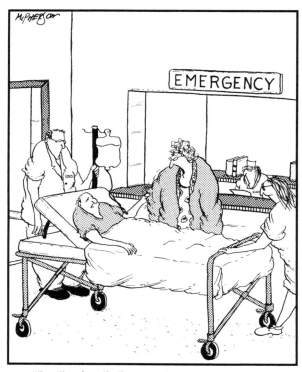

"For the fourth time, Hal, no, I won't forget
to get the parking stub validated!"

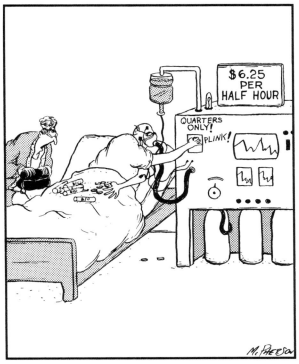

"Well, what'd you expect?! I've been telling you
for two years that we need health insurance!"

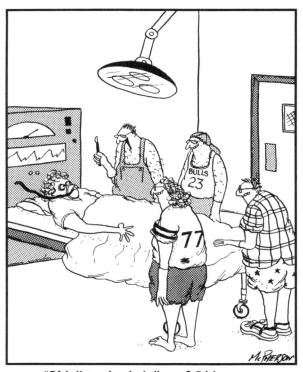

"Didn't anybody tell you? Fridays are
casual day in the O.R."

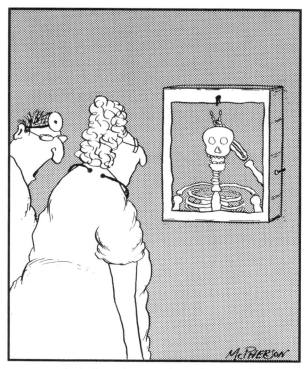

"Who's the wiseguy down in X-ray?"

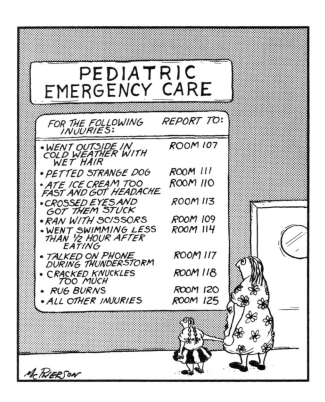

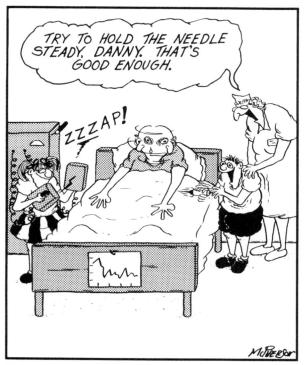

Take Your Child to Work Day at Fernview Hospital.

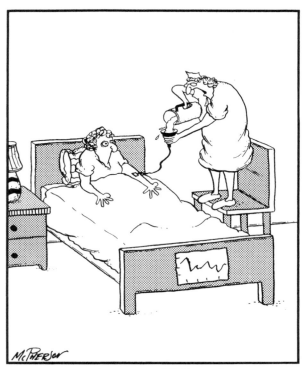

"We ran out of IV bags."

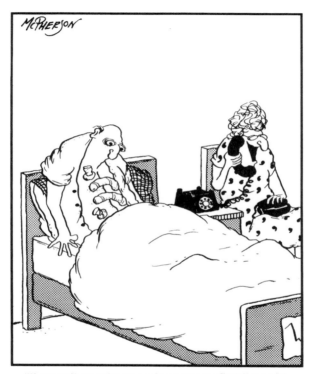

"It wasn't nearly as serious as we first thought.
He needed only two stitches."

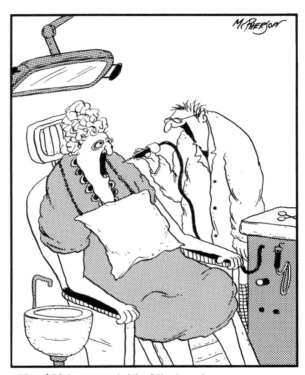

"For $20 I can get rid of that mole on your nose after I'm done filling this cavity."

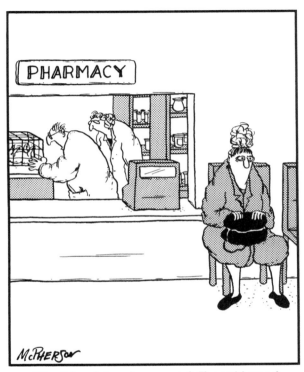

"No, this mixture is no good. The rat turned green and lost most of its fur. Let's go with 30mg of Xylonene. That should be fine for Mrs. Turner."

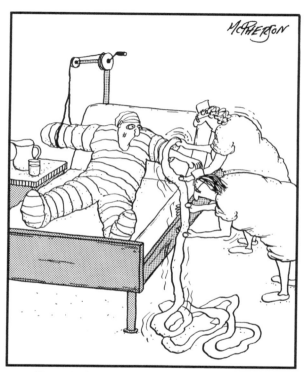

"Sorry to have to redo this, but Carol Ann
is pretty sure that her missing earring
is in here somewhere."

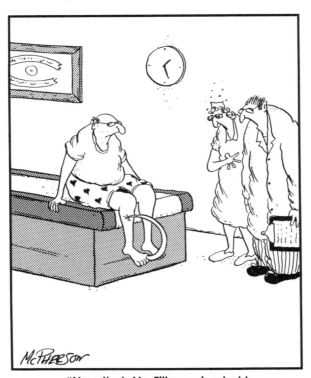

"Now *that*, Mr. Fillman, is what I call an ingrown toenail."

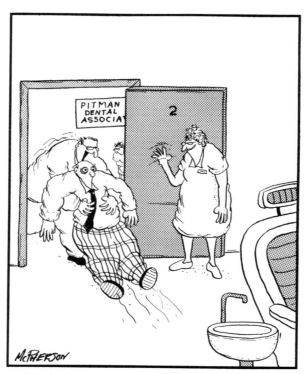

"You're just more affected by Novocain than
most people, Mr. Cromley. You should regain
full use of your legs in a day or two."

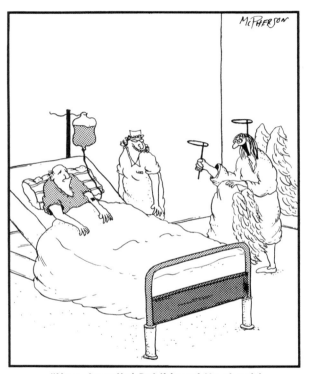

"Hey, Annette! Put this on! He should
be coming to any minute!"

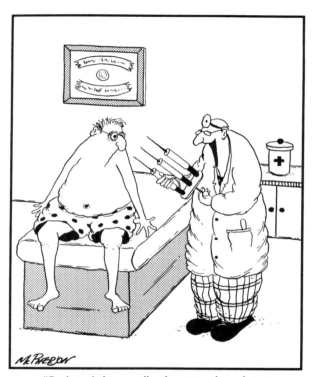

"Fortunately, medical researchers have been able to combine tetanus, smallpox, and rubella vaccinations into one shot."

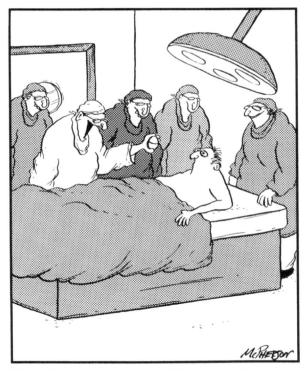

"Since it's almost certain you'll need another bypass in 10 years, we were wondering if we could implant this small time capsule in you as a gesture of goodwill to the surgeons who will work on you then."

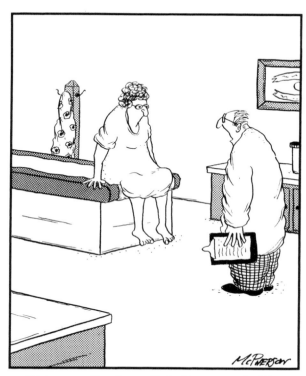

"I'm sorry, Mrs. Bennett, but to prevent office visits from dragging on, the HMO requires that I answer only 'yes' or 'no' questions."

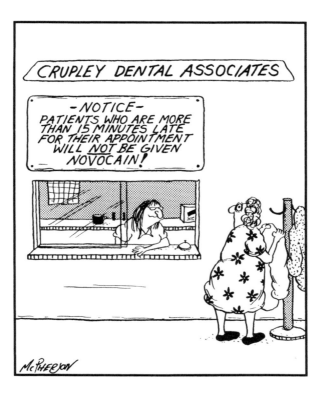

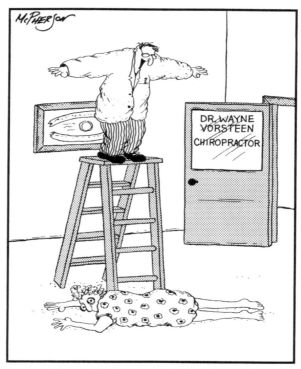

"I need to have you just relax and
trust me on this, Mrs. Hostrander."

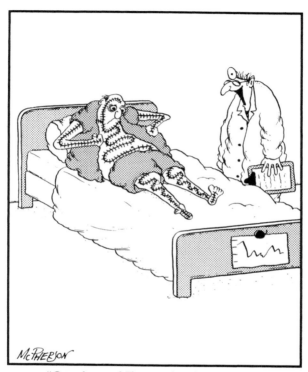

"Good news! The exploratory surgery
turned up negative."

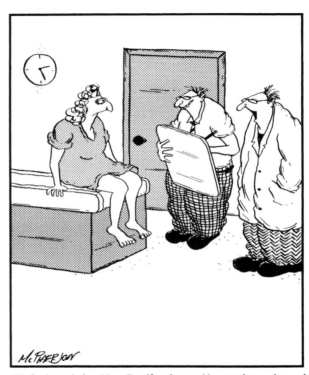

"Unfortunately, Mrs. Dortford, our X-ray department
is on strike. If you'll just give a detailed description
of your pain, our sketch artist will give us a
fairly accurate drawing of the problem."

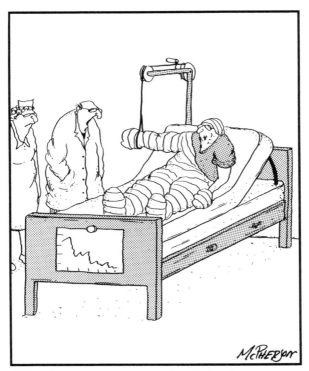

"Your insurance company is refusing to pay your
medical bills due to a pre-existing condition. It says
you were already an idiot before you decided
to Rollerblade down the interstate."

63

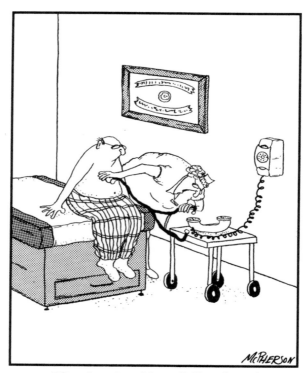

"Go ahead and tee off. Then I want
you to listen to this wheezing."

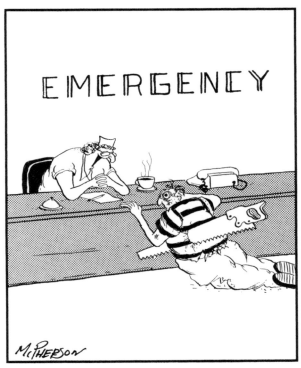

"I'm sorry, sir, but your insurance company
requires that you first get a referral slip from your
primary care physician before we can treat you."

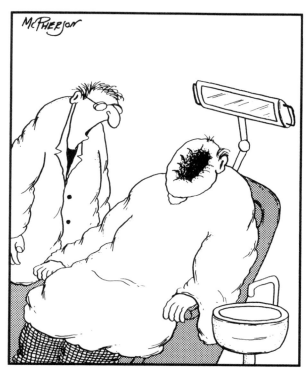

"You let that cavity go far too long."

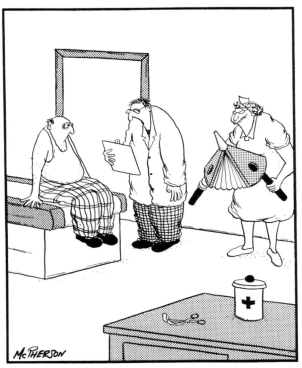

"Okay, Mr. Frawley . . . severe sinus congestion."

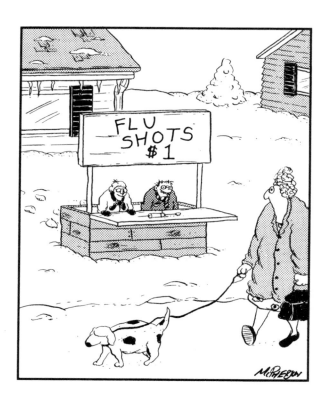

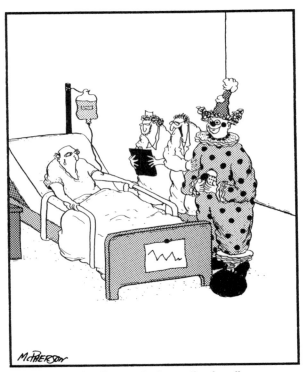

"We're conducting a study on the healing power of humor. As Boppy performs for you, let us know the precise moment that you feel the kidney stone pass."

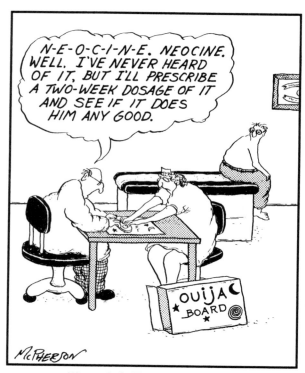

Wayne's faith in his new HMO
was eroding quickly.

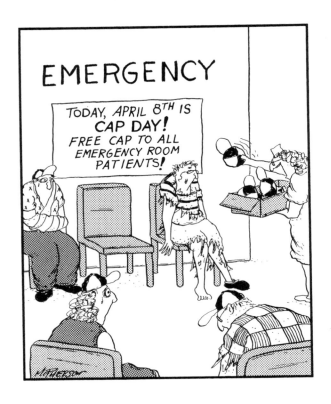

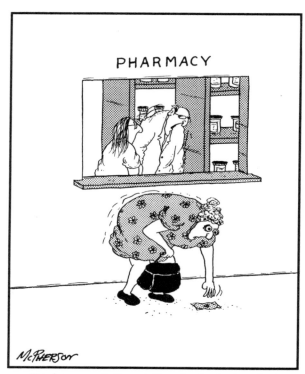

"Is she gone? Good. Her doctor just called and said she's a complete wacko. We're supposed to just give her a placebo prescription."

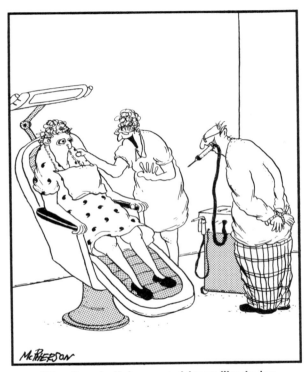

"Mrs. Brackett, how would you like to be
in the *Guinness Book of World Records*?"

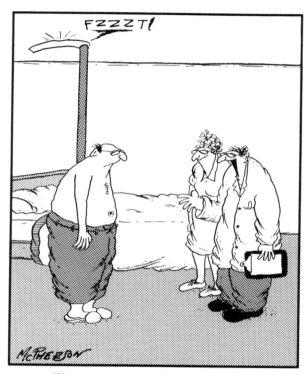

"Your new pacemaker operates on
the same principle as a bumper car
at an amusement park."

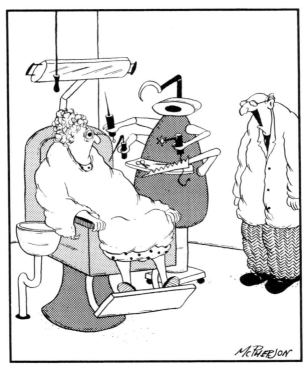

"Your root canal is pretty straightforward,
Mrs. Zagler, so I'm going to turn things over to the
Auto-Dentist. If you have any problems,
just pull on that cord above your head."